KEW POCKETBOOKS

FUNGI

Introduction by Lynn Parker
Curated by Gina Fullerlove

Kew Publishing
Royal Botanic Gardens, Kew

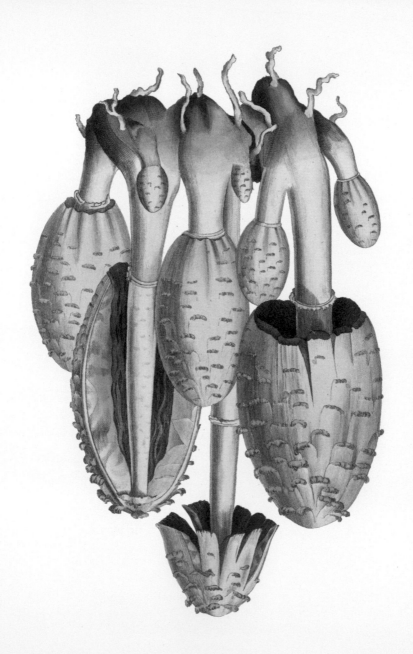

KEW HOLDS ONE OF THE LARGEST COLLECTIONS of botanical literature, art and archive material in the world. The Library comprises 185,000 monographs and rare books, around 150,000 pamphlets, 5,000 serial titles and 25,000 maps. The Archives contain vast collections relating to Kew's long history as a global centre of plant information and a nationally important botanic garden including 7 million letters, lists, field notebooks, diaries and manuscript pages.

The Illustrations Collection comprises 200,000 watercolours, oils, prints and drawings, assembled over the last 200 years, forming an exceptional visual record of plants and fungi. Works include those of the great masters of botanical illustration such as Ehret, Redouté and the Bauer brothers, Thomas Duncanson, George Bond and Walter Hood Fitch. Our special collections include historic and contemporary originals prepared for *Curtis's Botanical Magazine*, the work of Margaret Meen, Thomas Baines, Margaret Mee, Joseph Hooker's Indian sketches, Edouard Morren's bromeliad paintings, 'Company School' works commissioned from Indian artists by Roxburgh, Wallich, Royle and others, and the Marianne North Collection, housed in the gallery named after her in Kew Gardens.

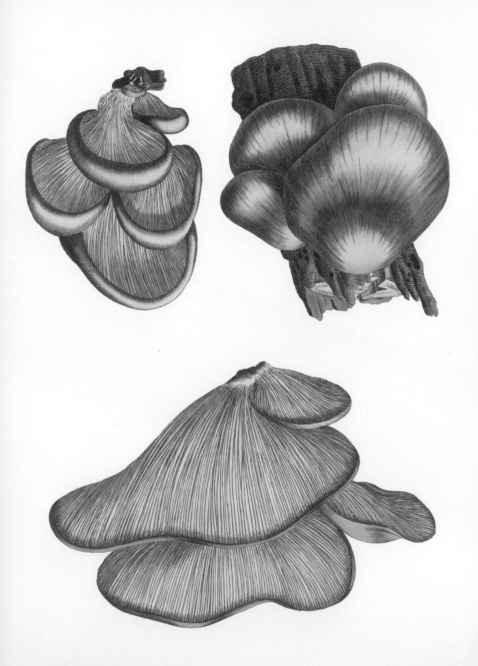

INTRODUCTION

ARCHAEOLOGICAL EVIDENCE SHOWS THAT HUMANS
have used fungi in food, drinks and medicine for at
least 6,000 years. Yet the study of fungi (mycology) has
remained in the shadows compared with research on
plants and animals. Many early writings assumed that they
were simple or lower plants. They are in fact a kingdom
in their own right, more closely related to animals than
plants. This is only one of a number of remarkable facts to
emerge in the past few decades; fungi are truly wonderful,
diverse and incredibly numerous.

These organisms often cannot be seen with the naked eye
and spend vast parts of their life cycle underground or
inside plants and animals. But it's now becoming apparent
that they play incredibly important environmental roles,
for example in the global cycling of nutrients, carbon
sequestration, and even the prevention of the formation of
deserts in some drought-prone regions of the world.

Fungi also underpin products and processes that we rely
on heavily in aspects of everyday life, from drugs to the
synthesis of biofuels, and cleaning up the environment
through bioremediation. Some have multiple uses, for

example, species of *Penicillium* are used in antibiotics, the manufacture of contraceptive pills and cheese production.

The global market in edible mushrooms is also huge and increasing. But some species of fungi can wreak havoc. Many gardeners will know of the problems with rusts, wilts and mildews caused by certain species of fungi, and throughout the world there is significant concern about the spread of fungal pathogens that are devastating crops and wild plant communities – a threat which seems to be increasing with climate change.

Fungi should definitely be viewed on a par with the plant and animal kingdoms. We have only just started to scratch the surface of knowledge of this incredible group of organisms. When looking for nature-based solutions to some of our most critical global challenges, fungi could provide many of the answers.

The Royal Botanic Gardens, Kew has had a Fungarium since 1879. Many notable figures have come came to examine its specimens, including Charles Darwin and the children's author Beatrix Potter, who was a keen mycologist. The Fungarium at Kew is the largest in the world and now has over 1.25 million specimens, a number that is growing daily as the global significance of this kingdom becomes more and more apparent.

Extracted from
Willis, K. J. (ed.) *State of the World's Fungi 2018*

The paintings in this book come from Kew's mycology illustrations collection. A good number are reproduced from originals by Elsie Wakefield (1886-1972); this book is in part a tribute to her. Born in Birmingham, educated in Swansea and at Oxford, Wakefield was a pioneer professional woman in the scientific civil service, publishing around 100 papers on fungi and plant pathology and two field guides on British fungi. She first came to Kew in 1910, specialising in mycology and cryptograms (plants and fungi that reproduce using spores rather than seeds), rising to Head of Mycology in 1915 before becoming Deputy Keeper of the Kew Herbarium for six years from 1945 to 1951. She was elected President of the British Mycological Society in 1929. She described and named many species of fungi from Britain and overseas, and was also a talented illustrator, producing watercolour drawings of the species she identified. The fungi genera *Wakefieldia* (Boletaceae family) and *Wakefieldiomyces* (Clavicipitaceae family) are named in her honour, as are a number of other species.

Kew holds Wakefield's original illustrations and also papers detailing her mycological work at Kew. These include correspondence and notes on fungi families, species and nomenclature. Her observations are accompanied by her own photographs and field sketches,

some of which relate to her popular field guide *The Observer's Book of Common Fungi* published by Warne in 1954.

Some of the most iconic illustrations of fungi reproduced here are from Wakefield's originals, for example *Amanita muscaria*, or fly agaric, see page 61. An archetype of traditional folklore, this red toadstool with its characteristic white spots is a powerful hallucinogen, which probably accounts for its historic association with 'faery folk'.

The edible morel *Morchella esculenta*, see page 45, comes in many sizes; some as small as a thumbnail, others as big as your hand. While they differ greatly in appearance, they all share a distinctive honeycomb outer surface that Wakefield notes in her species description. Her notes reflect her interest in the whole organism: its anatomy, structure and appearance, its habit and its uses. This fungus is used widely in cooking but should not be eaten raw. Wakefield's notes provided suggestions as to how this mushroom might be served – 'stewed with gravy, or stuffed with minced meat and crumbs and baked'.

The distinctive feature of puffballs is that they produce spores from an internal amorphous stomach-shaped sporing body, appropriately called a gasterothecium, which emits clouds of dust-like spores upon maturation.

Wakefield's illustration of the giant puffball *Calvatia gigantea*, see page 53, is accompanied by the following note on how best to cook them – 'Puffballs should be used only when quite young and solid white throughout, a state which can be ascertained by cutting them through. After cleaning and peeling the giant puffball may be cut in slices about half an inch thick and fired, with or without a coating of egg or batter. Seasoning should be added.'

Scientists today estimate that we have found only about 5 per cent of the 2.2 to 3.8 million fungal species that exist on Earth. Their vast extent has only come to light in the last few years from molecular studies; the majority cannot be seen and are only known from their DNA. Fungi can be found anywhere. The beautiful illustrations in this book represent a tiny proportion of the fungal kingdom, just a few examples of how fungi reveal themselves to us.

Lynn Parker
Illustrations & Artefacts Curator
Royal Botanic Gardens, Kew

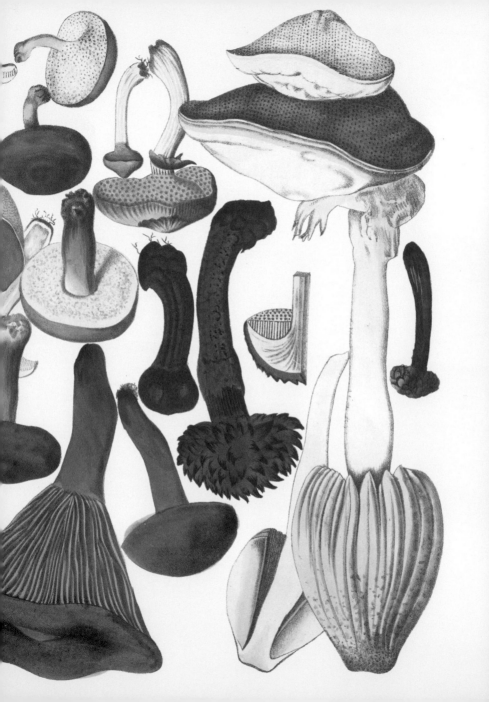

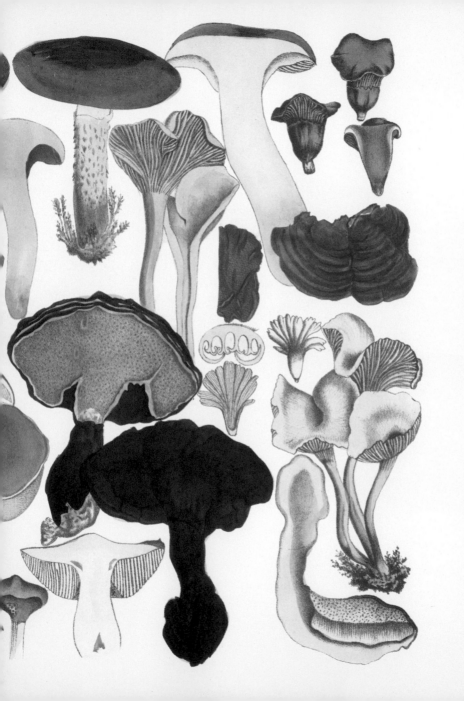

Macrolepiota procera

parasol mushroom

———————

by Elsie M. Wakefield
from the Kew Collection, c.1915–45

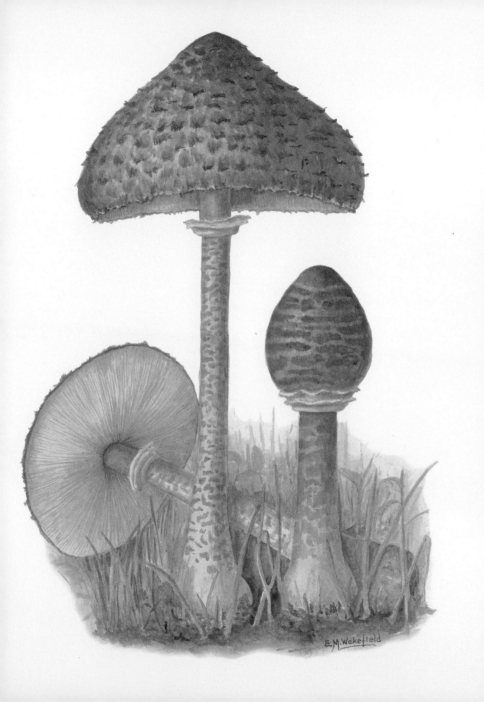

E.M.Wakefield

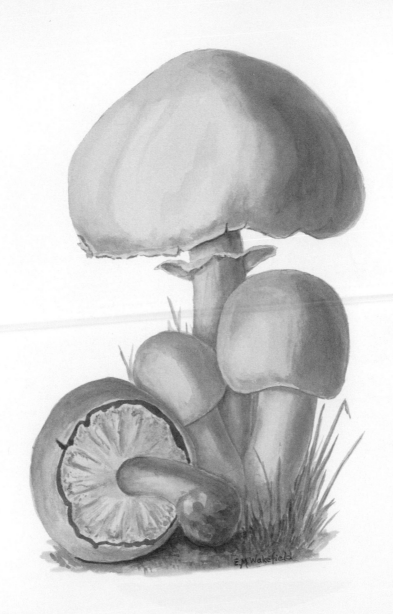

E.M.Wakefield

Agaricus arvensis

horse mushroom

by Elsie M. Wakefield
from the Kew Collection, c.1915–45

Lepista nuda

wood blewit

by Elsie M. Wakefield
from the Kew Collection, c.1915–45

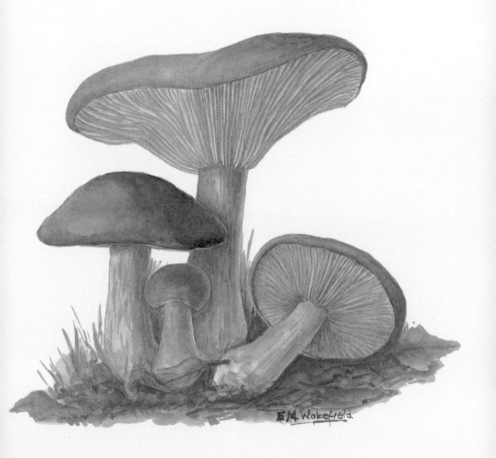

E.M. Wakefield

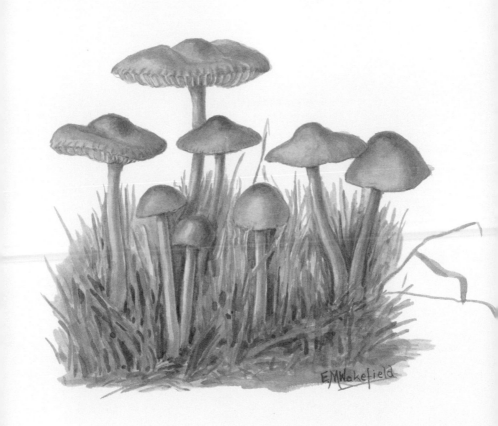

Marasmius oreades

fairy ring mushroom, champignon

by Elsie M. Wakefield
from the Kew Collection, c.1915–45

Leccinum scabrum

brown rough-stalked bolete, brown birch bolete

by Elsie M. Wakefield
from the Kew Collection, c.1915–45

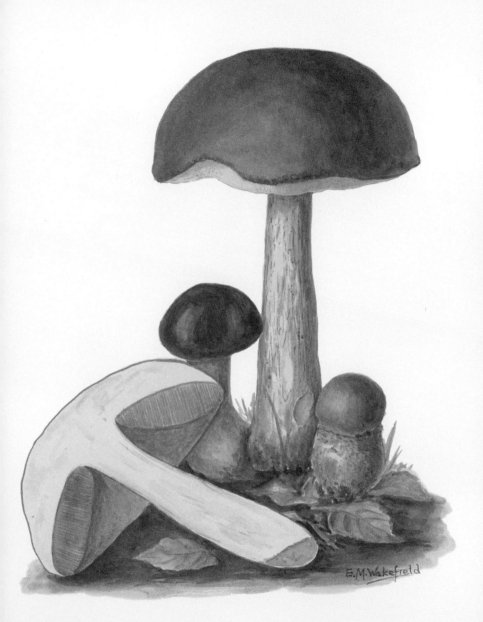

E.M.Wakefield

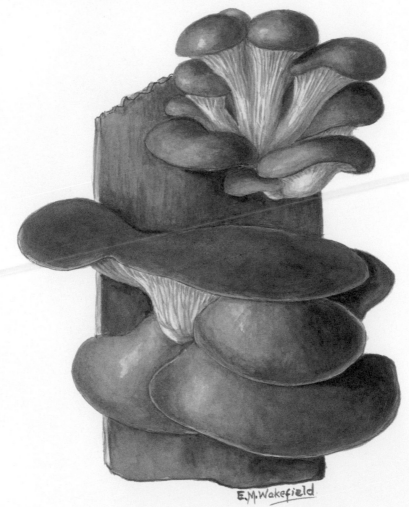

E.M.Wakefield.

Pleurotus ostreatus

oyster mushroom, hiratake

by Elsie M. Wakefield
from the Kew Collection, c.1915–45

Agaricus campestris

common field, meadow mushroom

by Elsie M. Wakefield
from the Kew Collection, c.1915–45

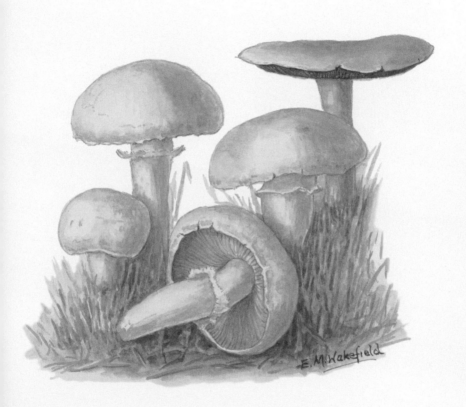

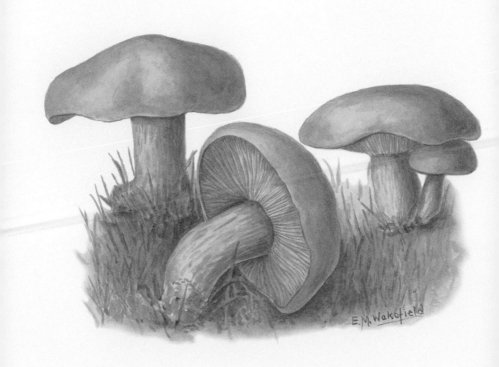

E.M.Wakefield

Nº 8

Lepista personata

field blewit, blue-leg

by Elsie M. Wakefield
from the Kew Collection, c.1915–45

Leccinum versipelle

orange birch bolete, rough bolete

by Elsie M. Wakefield
from the Kew Collection, c.1915–45

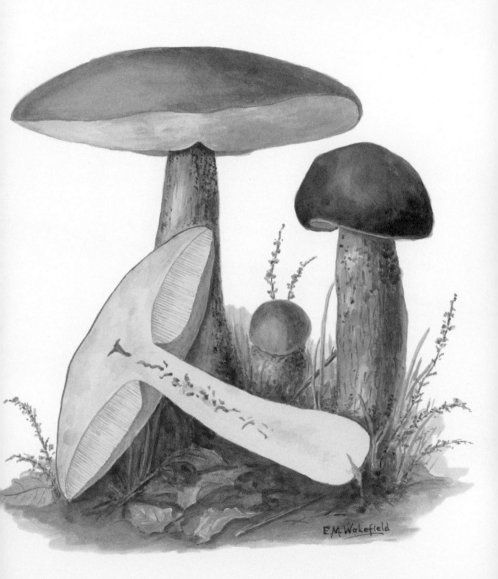

E.M.Wakefield

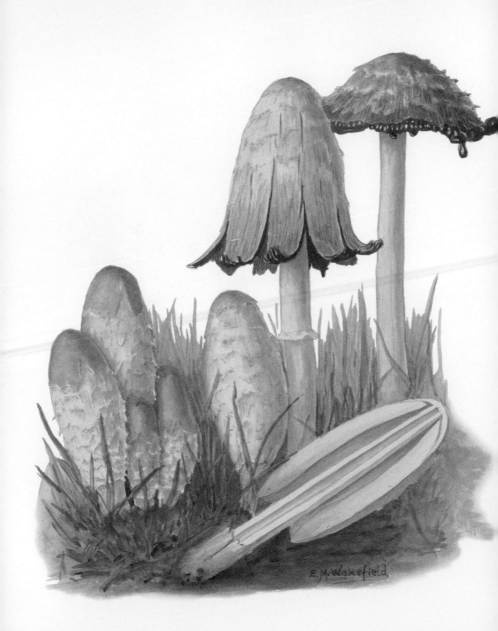

E.M.Wakefield

Coprinus comatus

shaggy ink cap, lawyer's wig, shaggy mane

by Elsie M. Wakefield
from the Kew Collection, c.1915–45

Cantharellus cibarius

golden chanterelle, girolle

by Elsie M. Wakefield
from the Kew Collection, c.1915–45

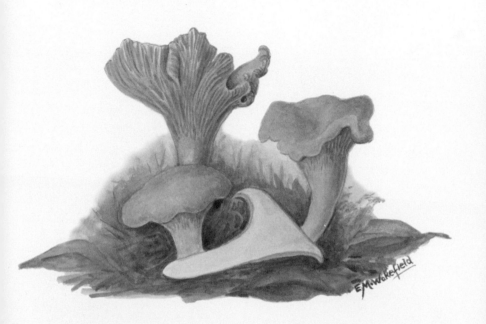

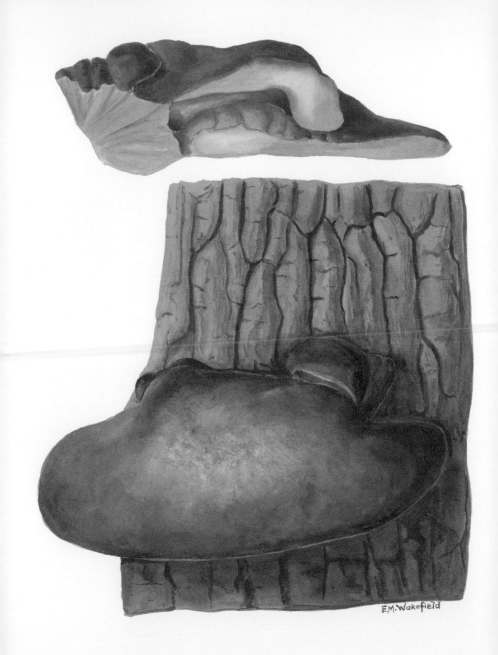

E.M.Wakefield

Fistulina hepatica

beef-steak fungus, tongue mushroom

by Elsie M. Wakefield
from the Kew Collection, c.1915–45

Calocybe gambosa

St George's mushroom

by Elsie M. Wakefield
from the Kew Collection, c.1915–45

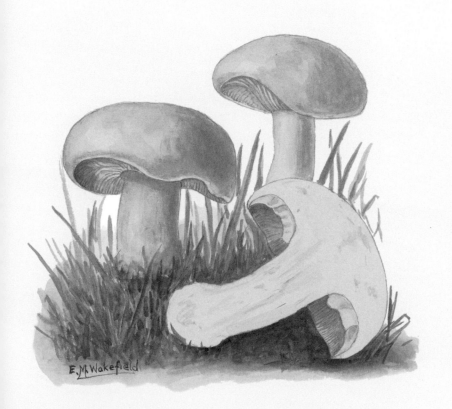

E. M. Wakefield

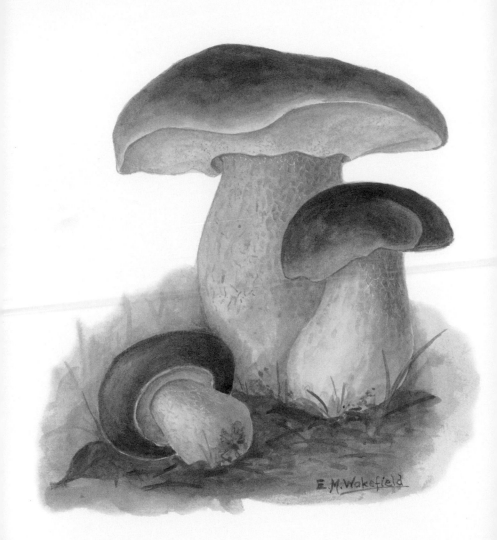

E. M. Wakefield

Boletus edulis

cep, penny bun, porcino

by Elsie M. Wakefield
from the Kew Collection, c.1915–45

Coprinopsis atramentaria

common ink cap

by Elsie M. Wakefield
from the Kew Collection, c.1915–45

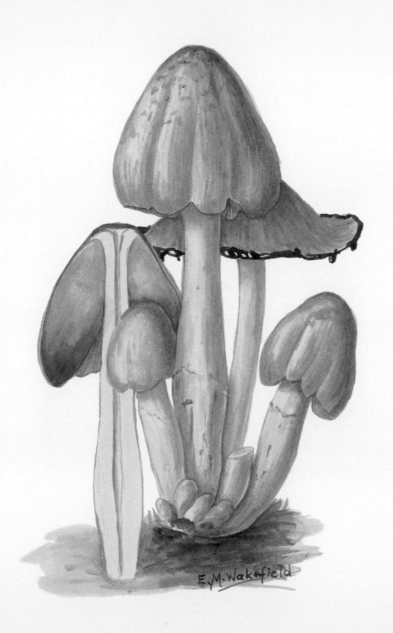

E.M. Wakefield

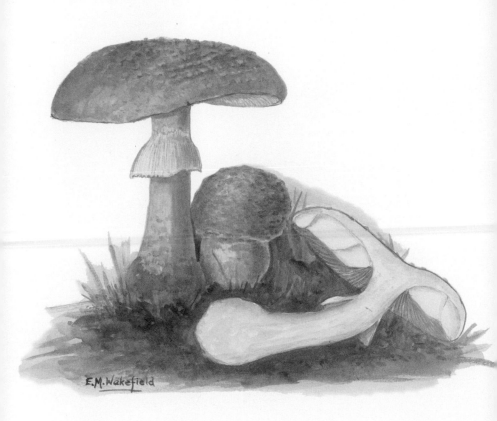

E.M.Wakefield

Amanita rubescens

the blusher

———

by Elsie M. Wakefield
from the Kew Collection, c.1915–45

Morchella esculenta

common or true morel, yellow morel,
sponge morel

by Elsie M. Wakefield
from the Kew Collection, c.1915–45

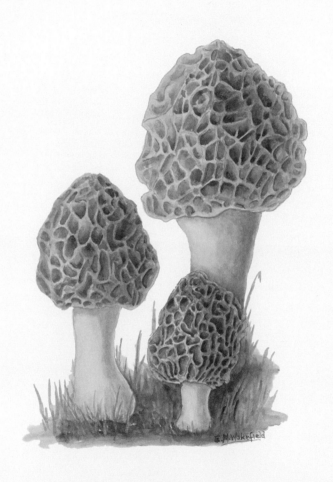

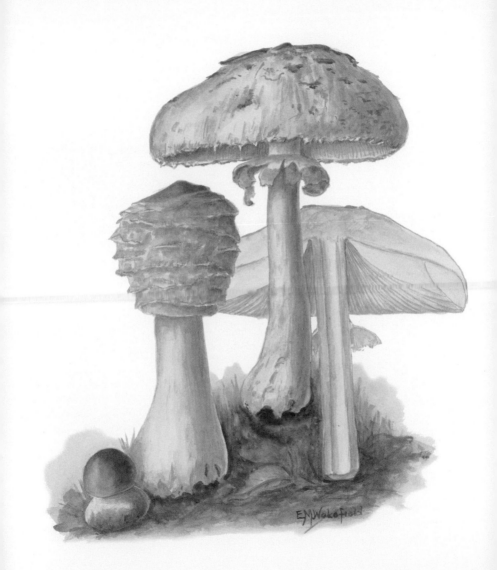

E.M.Wakefield

Chlorophyllum rhacodes

shaggy parasol

by Elsie M. Wakefield
from the Kew Collection, c.1915–45

Lactarius deliciosus

saffron milk cap, red pine mushroom

by Elsie M. Wakefield
from the Kew Collection, c.1915–45

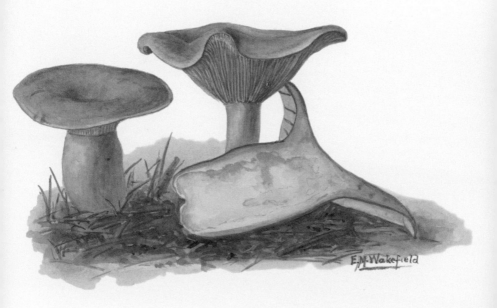
E.M. Wakefield

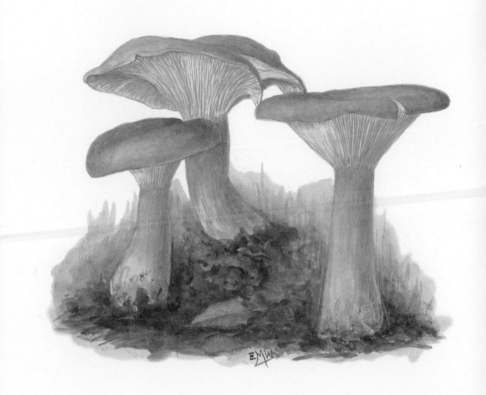

Clitocybe nebularis

clouded grey agaric, agaric, cloud funnel

by Elsie M. Wakefield
from the Kew Collection, c.1915–45

Calvatia gigantea

giant puffball

by Elsie M. Wakefield
from the Kew Collection, c.1915–45

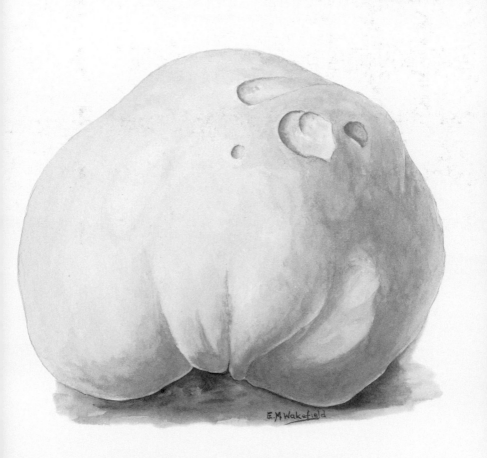

E.M.Wakefield

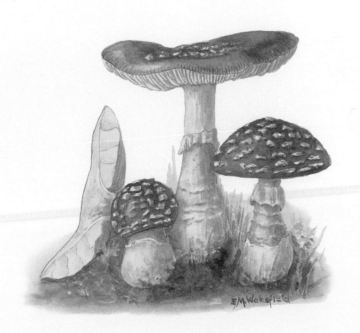

E.M.Wakefield

Amanita pantherina

panther cap, false blusher, panther amanita

by Elsie M. Wakefield
from the Kew Collection, c.1915–45

Amanita phalloides

death cap

by Elsie M. Wakefield
from the Kew Collection, c.1915-45

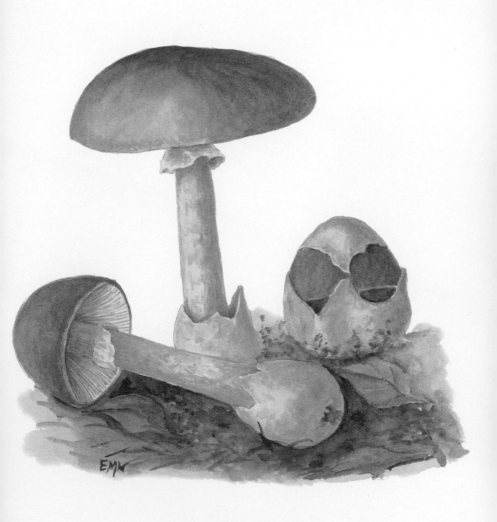

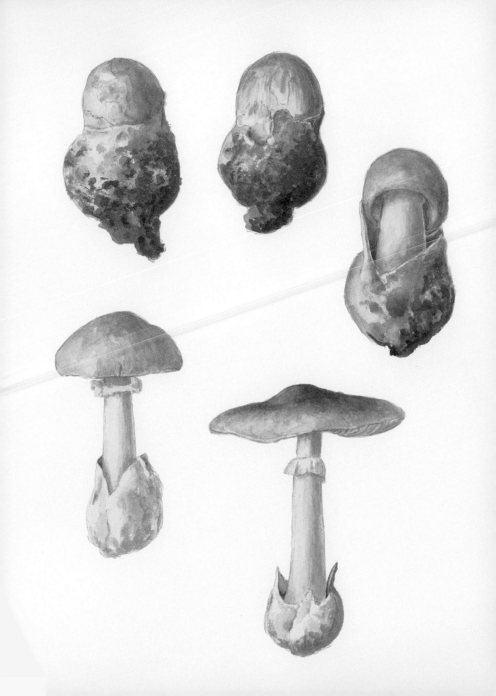

Amanita phalloides

death cap

by Elsie M. Wakefield
from the Kew Collection, 1944

Amanita muscaria

fly agaric

by Elsie M. Wakefield
from the Kew Collection, c.1915–45

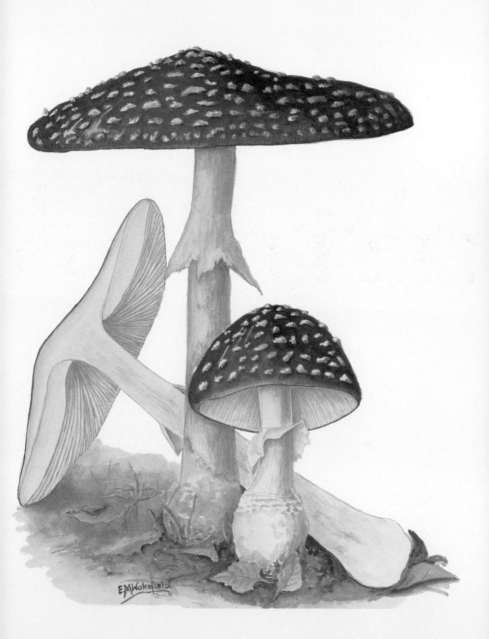

E M Wakefield

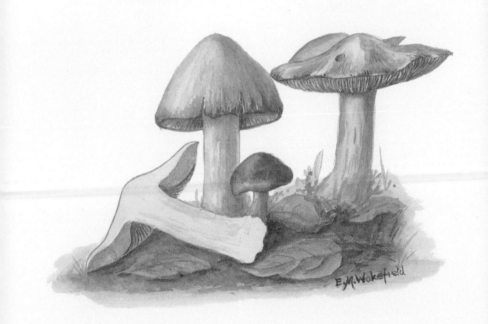

Inosperma erubescens

red-staining inocybe

by Elsie M. Wakefield
from the Kew Collection, c.1915-45

Laccaria amethystina

amethyst deceiver

from James Sowerby
Coloured figures of English fungi or mushrooms,
1795–1815

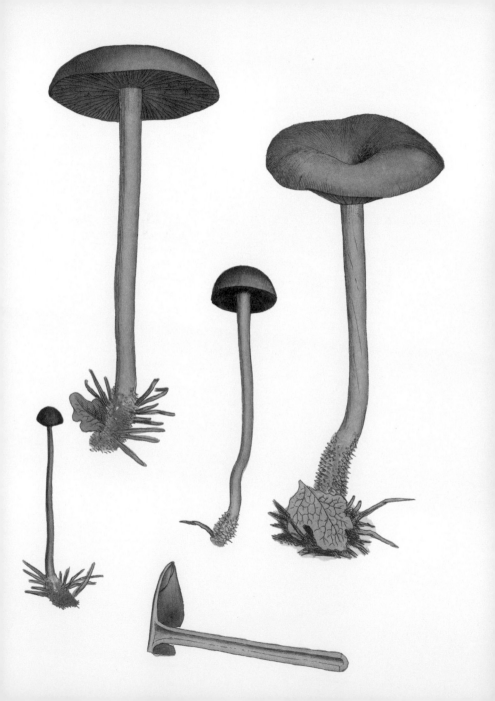

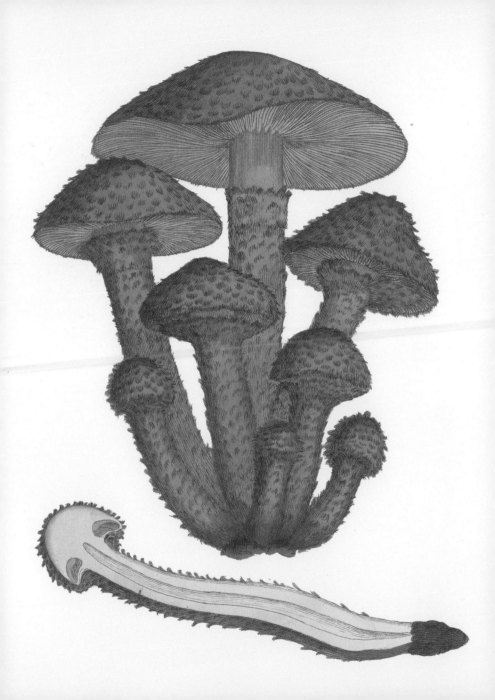

Pholiota squarrosa

shaggy scalycap

from James Sowerby
Coloured figures of English fungi or mushrooms,
1795–1815

Hydnoporia tabacina

reddish-brown crust

from James Sowerby
Coloured figures of English fungi or mushrooms,
1795–1815

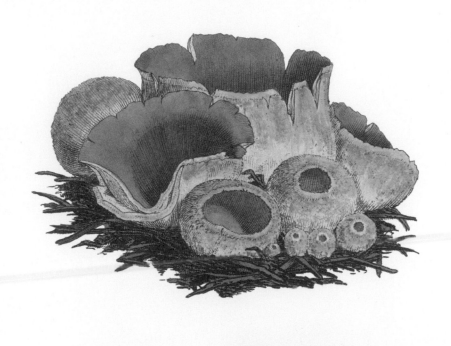

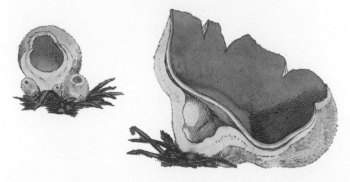

Peziza vesiculosa

blistered cup

from James Sowerby
Coloured figures of English fungi or mushrooms,
1795–1815

Scleroderma citrinum

common earthball, pigskin poison puffball

from James Sowerby
Coloured figures of English fungi or mushrooms,
1795–1815

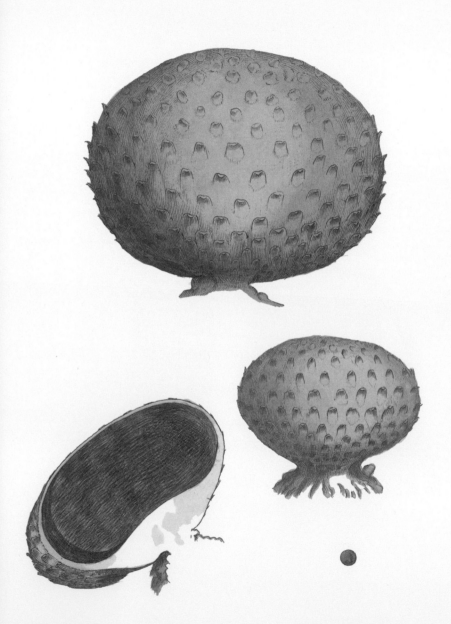

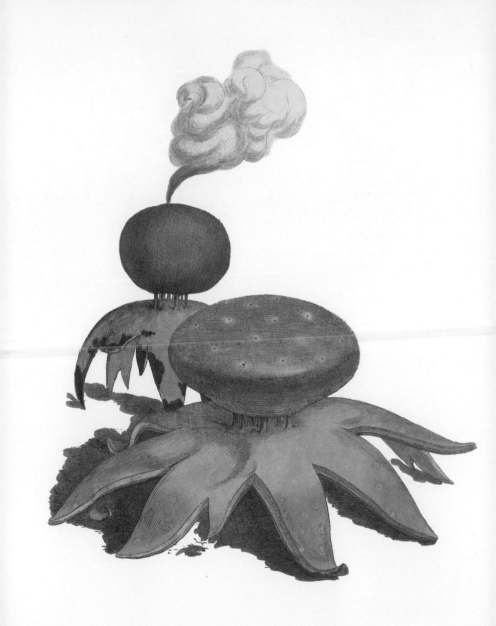

Myriostoma coliforme

salt-shaker earthstar, pepperpot

from James Sowerby
Coloured figures of English fungi or mushrooms,
1795–1815

Stropharia aeruginosa

verdigris roundhead mushroom

———————

from James Sowerby
Coloured figures of English fungi or mushrooms,
1795–1815

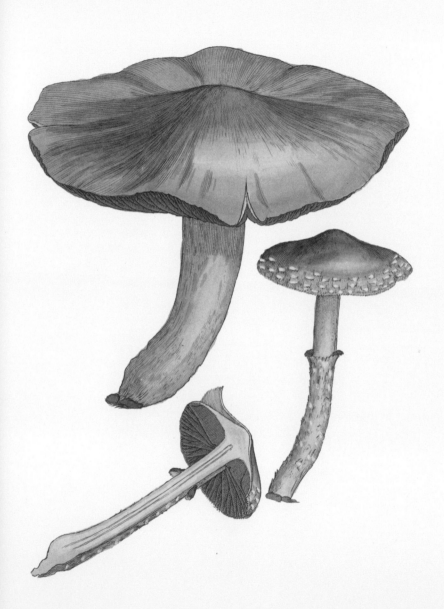

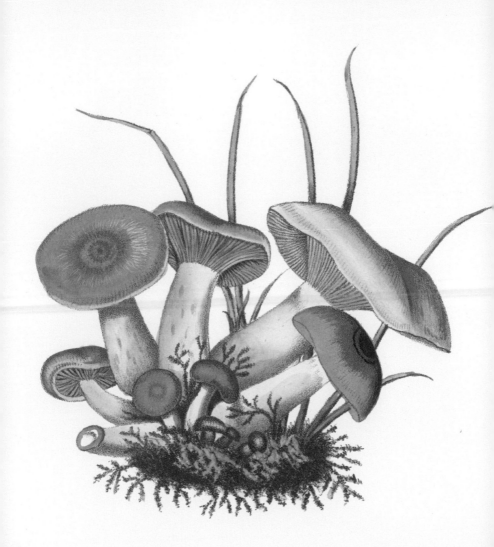

Lactarius deliciosus

saffron milk cap, red pine mushroom

from J. V. Krombholz *Naturgetreue abbildungen und beschreibungen der essbaren, schädlichen und verdächtigen schwämme, 1831–46*

Lobarina scrobiculata (1), *Lobaria pulmonaria* (2)

textured lungwort lichen (1), tree lungwort,
lung lichen, lung moss, lungwort lichen,
oak lungwort (2)

by Johann Stephan Capieux, 1789
from G. F. Hoffmann *Descriptio et adumbratio
plantarum e classe cryptogamica Linnaei quae
lichenes dicuntur*, 1790–1801

1

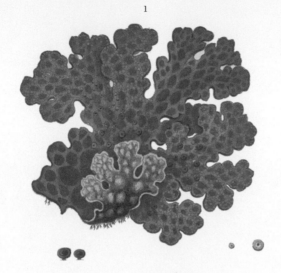

2

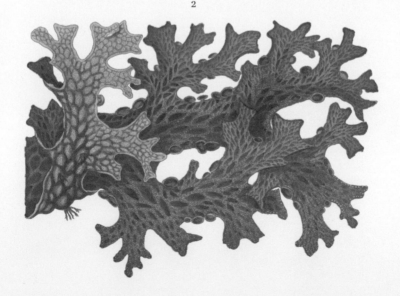

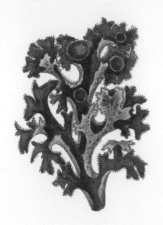

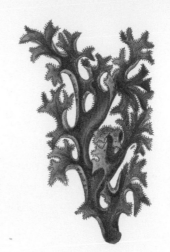

1

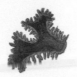

2

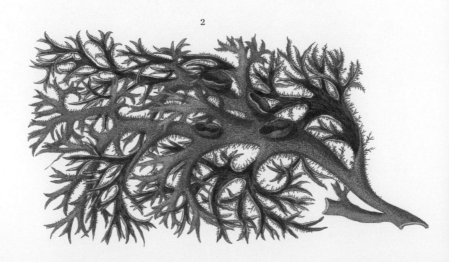

Cetraria islandica (1), *Pseudevernia furfuracea* (2)

Iceland moss lichen (1), tree moss lichen (2)

by Johann Stephan Capieux, 1789
from G. F. Hoffmann *Descriptio et adumbratio
plantarum e classe cryptogamica Linnaei quae
lichenes dicuntur*, 1790–1801

Usnea austroafricana (1), *Ricasolia virens* (2)

beard lichen (1), lichen (2)

by Johann Stephan Capieux, 1789
from G. F. Hoffmann *Descriptio et adumbratio
plantarum e classe cryptogamica Linnaei
quae lichenes dicuntur*, 1790–1801

1

2

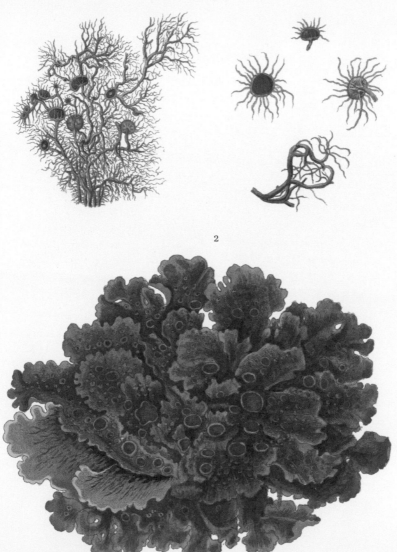

1

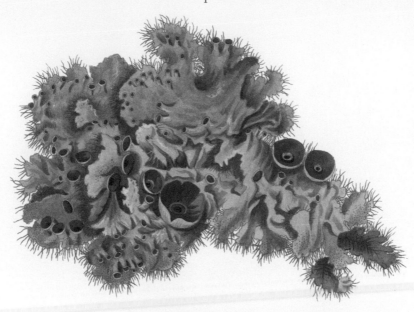

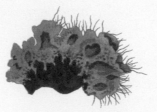

2

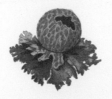

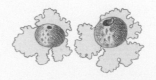

Parmotrema perforatum (1), *Parmelia omphalodes* (2)

ruffle lichen, scatter-rag lichen (1)

———————

by Johann Stephan Capieux, 1789
from G. F. Hoffmann *Descriptio et adumbratio
plantarum e classe cryptogamica Linnaei
quae lichenes dicuntur*, 1790–1801

?*Ramalina* sp.

strap, cartilage lichen

by Johann Stephan Capieux, 1789
from G. F. Hoffmann *Descriptio et adumbratio
plantarum e classe cryptogamica Linnaei
quae lichenes dicuntur*, 1790–1801

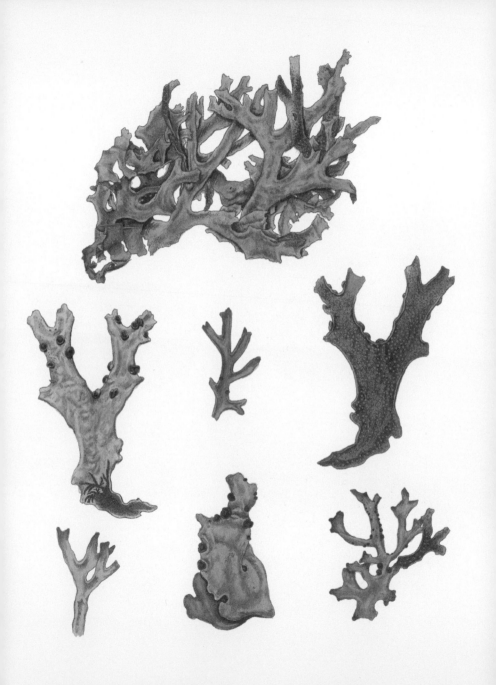

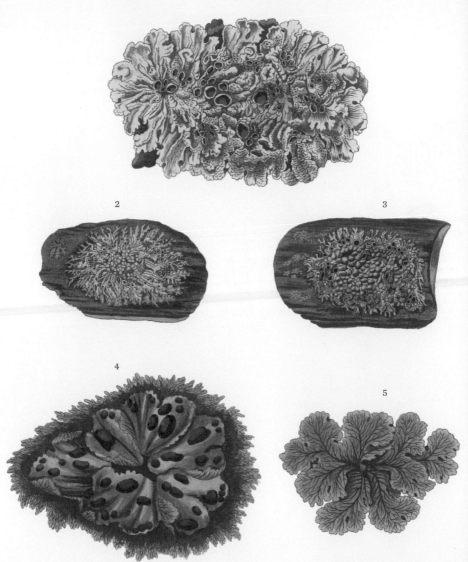

1

2 3

4 5

Flavoparmelia caperata (1),
Parmeliopsis ambigua (2–3),
Solorina crocea (4–5)

greenshield lichen (1), green starburst,
ambiguous bran lichen (2–3), orange
chocolate-chip lichen (4–5)

———————

by Johann Stephan Capieux, 1789
from G. F. Hoffmann *Descriptio et adumbratio
plantarum e classe cryptogamica Linnaei
quae lichenes dicuntur*, 1790–1801

ILLUSTRATION SOURCES

Books

Curtis, William. (1775–1798). *Flora Londinensis*. London.

Hoffmann, G. F. (1790–1801). *Descriptio et adumbratio plantarum e classe cryptogamica Linnaei quae lichenes dicuntur.* 3 volumes. Apud S. L. Crusium, Leipzig.

Krombholz, J. V. (1831–46). *Naturgetreue abbildungen und beschreibungen der essbaren, schädlichen und verdächtigen schwämme.* J.G. Calve'schen buchhandlung, Prague.

Sowerby, James. (1795–1815). *Coloured figures of English fungi or mushrooms.* 3 volumes. J. Davis, London.

Art Collections

Elsie M. Wakefield (1886–1972). Drawings, paintings, notebooks and writings, dating from 1910 to 1951, held in Kew's Library and Archives Collections. See Introduction pages 7–9.

FURTHER READING

Gaya, Ester *et al.* (2020). *Fungarium*. Big Picture Press, London in association with the Royal Botanic Gardens, Kew.

Kendrick, Bryce. (2017). *The Fifth Kingdom: An Introduction to Mycology*, 4th edition, Hackett Publishing Company Inc, Indianapolis and Cambridge, MA.

Kibby, Geoffrey. (2017–21). *Mushrooms and Toadstools of Britain & Europe*, 3rd edition. 3 volumes. Geoffrey Kibby.

Kirk, P. M., *et al.* (2008). *Dictionary of the Fungi*, 10th edition. CABI Publishing, Wallingford.

Phillips, Roger. (2006). *Mushrooms*. Macmillan, London

Roberts, Peter, J. & Evans, Shelley. (2021). *Fungi: A Species Guide. Gems of Nature* series. Ivy Press, London.

Sheldrake, Merlin. (2020). *Entangled Life: How Fungi Make Our Worlds, Change Our Minds and Shape Our Futures.* The Bodley Head, London.

Spooner, Brian M., Roberts, Peter J. (2005). *Fungi. New Naturalist Library* series. Harper Collins, London.

Online

www.biodiversitylibrary.org – the world's largest open access digital library specialising in biodiversity and natural history literature and archives, including many rare books.

www.britmycolsoc.org.uk – British Mycological Society, offering information on research, conservation, events and educational resources.

www.lichenology.org – International Association for Lichenology, promoting study and conservation of lichens.

www.kew.org – Royal Botanic Gardens, Kew website with information on Kew's science, collections and visitor programme.

www.kew.org/science/collections-and-resources/collections/fungarium – more about Kew's Fungarium, one of the largest, oldest and most scientifically important mycological collections in the world.

www.ima-mycology.org – International Mycological Association with links to national organisation around the world.

www.speciesfungorum.org – co-ordinated by the Royal Botanic Gardens Kew, this checklist database gives current names for over 147,000 fungal species.

https://stateoftheworldsfungi.org – online report edited by K.J. Willis, *State of the World's Fungi 2018,* prepared by an international team of researchers, with numerous facts and figures, published by the Royal Botanic Gardens, Kew.

https://data.nal.usda.gov/dataset/us-national-fungus-collections – US National Fungus Collections, including materials formerly held by the Smithsonian Institution.

ACKNOWLEDGEMENTS

Kew Publishing would like to thank the following for their help with this publication: Kew Fungarium Collections Curator, Lee Davies; mycologists Paul Cannon, Tuula Niskanen; in Kew's Library & Archives, Fiona Ainsworth, Craig Brough, Julia Buckley, Kat Harrington, Arved Kirschbaum, Anne Marshall, Lynn Parker, and Kiri Ross-Jones; for digitisation work, Paul Little.

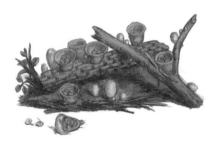

INDEX

Royal Botanic Gardens Kew

Reprinted in 2023
First published in 2021
Royal Botanic Gardens, Kew,
Richmond, Surrey, TW9 3AB, UK
www.kew.org

ISBN 978 1 84246 726 8

Distributed on behalf of the Royal Botanic Gardens, Kew in North America by the University of Chicago Press, 1427 East 60th St, Chicago, IL 60637, USA.

British Library Cataloguing in Publication Data
A catalogue record for this book is available from the British Library

Design: Ocky Murray
Page layout and image work: Christine Beard
Production Manager: Georgina Hills
Copy-editing: Michelle Payne

Printed and bound in Italy by Printer Trento srl.

MIX
Paper | Supporting responsible forestry
FSC® C015829

Front cover image: *Amanita muscaria* (see page 60)

Endpapers: Tafein 6 from J. V. Krombholz *Naturgetreue abbildungen und beschreibungen der essbaren, schädlichen und verdächtigen schwämme*, 1831–46

p2: *Coprinopsis atramentaria*, common ink cap from William Curtis *Flora Londinensis*, 1775–98

p4: *Pleurotus ostreatus*, oyster mushroom, hiratake from William Curtis *Flora Londinensis*, 1775–98

p10–11: Tafen 4 from J. V. Krombholz *Naturgetreue abbildungen und beschreibungen der essbaren, schädlichen und verdächtigen schwämme*, 1831–46

p94: *Crucibulum laeve*, white-egg birds nest from James Sowerby, *Coloured figures of English fungi or mushrooms*, 1795–1815

For information or to purchase all Kew titles please visit shop.kew.org/kewbooksonline or email publishing@kew.org

Kew's mission is to understand and protect plants and fungi, for the wellbeing of people and the future of all life on Earth.

Kew receives approximately one third of its funding from Government through the Department for Environment, Food and Rural Affairs (Defra). All other funding needed to support Kew's vital work comes from members, foundations, donors and commercial activities, including book sales.

Publisher's note

The scientific names of the fungi featured in this book are current accepted names according to Species Fungorum at the time of going to press. They may differ from those used in original-source publications. The common names given are those most often used in the English language, or sometimes vernacular names used for the plants in their native countries.

This book should not be used as a field or identification guide. Never forget that the fungus in your hand may not be included in any guide you have, might not have been found before in the country or may even be new to science! The best way to start becoming familiar with fungi of all kinds is to join field meetings organised by mycological societies where you can learn from experienced mycologists.